GOLDEN
COLORADO

IMAGES
of America

Bird's-eye maps were quite popular during the late 19th century. They tended to be highly stylized views of the town layout. Golden was the subject of several of these, including this one from 1873. Few copies of this one survive; one is on exhibit at the Golden Pioneer Museum.

IMAGES of America
GOLDEN COLORADO

Golden Pioneer Museum

ARCADIA

Copyright © 2002 by Golden Pioneer Museum.
ISBN 0-7385-2074-8

Published by Arcadia Publishing,
an imprint of Tempus Publishing, Inc.
3047 N. Lincoln Ave., Suite 410
Chicago, IL 60657

Printed in Great Britain.

Library of Congress Catalog Card Number: 2002108510

For all general information contact Arcadia Publishing at:
Telephone 843-853-2070
Fax 843-853-0044
E-Mail sales@arcadiapublishing.com

For customer service and orders:
Toll-Free 1-888-313-2665

Visit us on the internet at http://www.arcadiapublishing.com

Erected in 1949 by Lu and Ethel Holland, the Golden Arch has welcomed visitors to town in classic neon style. It has been renovated several times. During its 1970s facelift, the motto was changed from "Where the West Remains" to "Where the West Lives" because "remains" sounded overly negative to many people. The Arch is now on the State Register of Historic Places, spanning Washington Avenue, Golden's main thoroughfare, between Twelfth and Thirteenth Streets.

Contents

Acknowledgments		6
Introduction		7
1.	A Golden Opportunity	9
2.	From Capital to County Seat	27
3.	Mercs, Mills, and Rocky Mountain Spring Water	37
4.	Gold Fever!	55
5.	Supporting the Troops	63
6.	Where the West Plays!	75
7.	Traveling Through History	91
8.	A Higher Standard: Education on the Frontier	101
9.	Golden Moments	111

Acknowledgments

The Board of Directors and staff of the Golden Pioneer Museum extend their heartfelt gratitude to all those who lent their assistance, expertise, and resources to this project: the Colorado Historical Society, the Denver Public Library, the Gilpin County Historical Society, the Colorado Railroad Museum, the Astor House Museum, Clear Creek History Park, Lorraine Wagenbach, Albert Hansen, the Harmsen Family, the Young Family, Le Roy and Beverly Allen, the Holland Family, and Dennis Potter.

INTRODUCTION

Golden, Colorado, grew up as a western town neither "rough and ready" nor properly "gentrified." It was a town isolated from its neighbor and chief competitor, Denver, yet it managed to attract the attention of people worldwide. The town served as the transition between the blue collar, hard scrabble mountain enclaves of Central City and Black Hawk and the white-collar financial center of Denver. Golden was, and is, a study in contrasts—neither blue collar nor truly white collar; it was neither mountain nor plain; yet it drew a myriad of entrepreneurs, world travelers, and adventurers from all corners of the globe.

Situated between the Great Plains and the foothills of the Rocky Mountains, bisected by the Clear Creek, is a scenic valley bordered to the east by two imposing mesas. This valley has been inhabited, in one form or another, for about 12,000 years. First utilized by the Native Americans as a seasonal hunting ground, and later as the seat for one of Colorado's oldest counties, Golden has a long and rich history full of colorful characters, unique events, discoveries and inventions that have shaped the world, and people that have left an indelible impression on American society.

Archaeologists have established sound data that the ancestors of the Ute, Comanche, Kiowa, Apache, and numerous other tribes lived and hunted in the valley as early as 12,000 years ago. These nomadic people left behind only the remains of their campsites. These sites now bear such English names as Magic Mountain and Hall-Woodland Cave. Very few accounts of early Golden speak of the native peoples. One legend holds that the Arapaho would not descend from the mesa tops into the valley; they spoke of a bad thing that happened there and caused the valley to be forbidden to their people. Other accounts mention a trading post, situated somewhere in the valley, that welcomed the Ute, Cheyenne, and Arapaho. There are no known photographs of the First Peoples from this part of the Clear Creek Valley.

Explorer Major Stephen H. Long penned the first written records of the Clear Creek Valley in 1820. A hunting party was sent west from the Platte River camp. The men killed a pronghorn antelope (*Antilocapra americana*) along the banks of the Cannonball Creek. The creek had secured its moniker from French trappers who thought the large stones in the water looked like cannonballs. The name was soon to change when French-Canadian trader Louis Vasquez traversed the valley in 1832 looking to establish a trading post. He called the area Vasquez Forks. That name stuck, though it generally is applied to just the area where the north and south branches of the Clear Creek come together. Later visitors to the valley proclaimed the creek Clear—because the fish were visible quite readily beneath the waters.

While historians are able to trace the various names applied to the creek, they cannot so readily trace the origins of the name of the town that straddles the creek's banks. Golden's moniker, established in 1859, remains shrouded in mystery. It was not named for the first landowning settler in the valley, David Wall. It could have been named for an early political candidate, Thomas Golden; however Golden never owned land here, and left very soon after losing the election. Just to the west of the town is a unique stone escarpment bearing remarkable resemblance to a gate. It was named, early on, the Golden Gate. A small town sprang up close by called Golden Gate City; it is possible, though unlikely, that Golden's name was related to this feature.

Throughout the years of the Colorado gold and silver booms, Golden served as the gateway to the mining districts. Railcars filled with all the wealth of the mountains flowed through the heart of the little town. Businesses of all types, including smelters, brickyards, paper mills, flour mills, and, of course, saloons, sprang up to meet the needs of the thousands of fortune-seekers and their families seeking wealth and a new life. One commonly held belief is that Golden's founding father, George West, foresaw the advent of these very industries, and assigned the moniker Golden, while he platted the town, anticipating those myriad golden business opportunities.

However Golden received its appellation, the town has indeed lived up to its name. She is home to the Coors Brewing Company, the Colorado School of Mines, the National Earthquake Center, and became the gateway to the Richest Square Mile on Earth. Inventions that have altered the shape of American life have been created here, including the narrow gauge railroad, porcelain bomb casings, and various mining processes. In addition, she is a sportsman's paradise, offering fishing, kayaking, rock climbing, hiking, and hang gliding. Tourism is one of the town's largest industries.

Modern day Golden faces the same struggles as all small towns—balancing the economic viability of the town with the need to reign in growth, maintaining a vibrant resident population yet meeting the needs of today's tourist, as well as finding new and creative ways to succeed in the new millennium. Golden sits just 12 miles west of the large Denver metropolis; she has fought throughout her history to avoid being overshadowed by her sister frontier town to remain as the town Where the West Lives.

The majority of the following images are drawn from the collection of the Golden Pioneer Museum. The Museum owns over 1,000 images related to the wonderful history of Golden, Colorado. Founded as a Works Progress Administration Project in 1938, the Golden Pioneer Museum is the oldest museum in the city. Its collections range from Native American dolls to historic clothing and home furnishings. The Golden Pioneer Museum is located at 923 Tenth Street in historic downtown Golden.

One
A GOLDEN OPPORTUNITY

The Pikes-Peak-or-Bust Gold Rush brought over 100,000 people to the Jefferson Territory's Front Range. Many of the gold-seekers passed through a small settlement on the banks of the Clear Creek; at the time it was little more than a tent-city of farmers and would-be ranchers. This establishment of 1,280 acres would become the town site of Golden City in 1860. It had about 700 inhabitants. Additional towns were established simultaneously along the creek, including Arapahoe Bar, Golden Gate City, and Mt. Vernon City; the steadily expanding borders of Golden City eventually engulfed them. This image was taken in the 1870s.

Golden City consisted of a small tent city and a few farms on the creek when it was "discovered" in 1859 by two entrepreneurs from the East Coast. The men, George West and William Loveland, saw a golden business opportunity in the valley that sat at the entrance to the gold-rich mountains. They began construction of a real town almost immediately. The Loveland Building, pictured in the background, was one of the early permanent structures.

William Austin Hamilton Loveland, a veteran of the Mexican-American War, came to the territory seeking a new life as a businessman. During his time in Golden, Loveland owned a mercantile, constructed the first road up the Clear Creek Canyon, established the Colorado Central Railroad, and served as the treasurer for Golden City, among other notable accomplishments. In 1862, Loveland successfully brought the capitol of the newly formed Colorado territory to Golden, where it stayed until 1867. A mountain pass, a ski area, and a town bear his name.

Among the many colorful characters of Golden's early years is George West. Arriving in June 1859 as the wagonmaster for the Mechanics Mining & Trading Company of Boston, Massachusetts, West constructed the first permanent building in town and founded the town's first newspaper, *The Western Mountaineer*. West was known for telling a good story and an even better lie; he purportedly challenged a man to a duel to be fought from two mesa tops using Bowie knives. The duel never took place, but West's bravado took its place in history.

Edward L. Berthoud, Swiss by birth, served as an assistant engineer on the Trans-Panama railroad in 1851. He arrived in Golden in 1860. Working for W.A.H. Loveland, Berthoud surveyed the wagon road up Clear Creek Canyon. With renowned mountain man Jim Bridger, he surveyed a rail route through Middle Park; the pass bears Berthoud's name. After serving with the Second Colorado Cavalry in the Civil War, Captain Berthoud taught geology and civil engineering as one of the first faculty members at the State School of Mines.

In 1859, David Wall and family settled along the banks of Clear Creek. He was not a prospector, nor a town builder; he was a farmer. Wall's farm was a respectable-sized operation, 160 acres, incorporating the first recorded use of agricultural irrigation in the Central Plains. In his first year, Wall realized about $2,000 in profits, selling vegetables throughout the Front Range. Wall provided money to John Gregory to prospect in Gilpin County. Gregory went on to discover the gold vein that gave rise to the Richest Square Mile on Earth. This image is not of the Wall farm, but of a later farm within the valley.

Life in the Territory was often difficult and frequently lonely. Nan Scott wrote of these trials to her sister in September 1864. It took them six weeks and two days over hard roads from Iowa to reach Golden City. She notes that it is very expensive here: 22¢ a pound for flour, 30 ¢ a pound for bacon, and $1 each for watermelon. Also prominent in the letter is talk of a vicious Indian attack on white settlers; this highly sensationalized and somewhat falsified account gave rise to the Sand Creek Massacre later that same year.

14

The *Colorado Transcript*, founded by George West in 1866, is one of the oldest continuously printed newspapers in Colorado. West had a decidedly Democratic slant to his paper and in the 1870s had a very pronounced rivalry with competing newspaperman William Byers of the *Rocky Mountain News*. The paper, now called the *Golden Transcript*, remains as Colorado's oldest weekly paper still in production.

In the September 11, 1867 edition of the *Rocky Mountain News*, William Byers noted that, "The Territory of Colorado has five daily newspapers, eight weeklies, and two monthlies, one devoted to Sunday Schools, and the other to temperance. We believe the people of Colorado sustain more newspapers and support them better than does any other western state or territory of the same size." The *Colorado Transcript*, pictured here in about 1913, would have been one of those weeklies to which Byers referred.

On July 17, 1859, the Reverend Jacob Adriance was sent out to organize Golden's first Methodist Episcopal Church. The first service was held on July 4, 1859, in a gambling tent with Adriance using a whiskey barrel as a pulpit. It wasn't until 1869 that the small group of worshippers constructed their own sanctuary. They are the second oldest Methodist congregation in Colorado with the longest operating Sunday school (1860).

Calvary Episcopal was founded in 1867. It is considered the surviving pioneer church because it is the only one of the early churches that still inhabits the original structure. The red brick building is located across from the National Guard Armory in downtown Golden. It began with a $1,000 gift and donated land. Both William Loveland and Edward Berthoud were members of the Calvary Episcopal Church; Berthoud served as one of the original vestry; Loveland was the first treasurer.

The Reverend Lewis Hamilton founded Golden's first Presbyterian Church on April 30, 1860. There were four charter members. The group hired Minister Reverend J. Gibson Lowrie in 1871 to lead them in founding their permanent home. The modified Gothic stone structure was dedicated in 1872. The church's first collection of $6.35 occurred in 1871, followed by the first communion celebration.

Easter Services

at the

Presbyterian Church

SUNDAY, APRIL 23, 1905
GOLDEN, COLORADO

Fr. Joseph Machebeuf founded St. Joseph's Catholic Church in 1859, though there were only two Catholic families in town at the time. The Church was dedicated on May 19, 1867, and was attended by many non-Catholics because it was such a fine structure. A brick church was constructed in 1899 to replace the frame building. Machebeuf went on to become a noted Denver bishop.

Pictured in 1875, the altar of St. Joseph's Church embodies the spirit of the Altar Society. The Society provides for the adornment of the altar. They believe that every member of the Church should consider it an honor and a duty to promote whatever enhances and beautifies divine worship. (Courtesy of Lorraine Wagenbach.)

"Golden City by daylight showed its meanness and belied its name. It is upgraded, with here and there, a piece of wooden sidewalk, supported on posts, up to which you ascend by planks. Brick, pine, and log houses are huddled together, every other house is a saloon, and hardly a woman is to be seen." (Courtesy of Isabella Bird, *A Lady's Life in the Rocky Mountains*.)

Golden as seen from South Table Mountain, c. 1870, shows the rapid growth of the town since the preceding decade. At the time, Golden had only about 1,000 residents and would have appeared very rustic to world-traveler Isabella Bird. However, it was still larger than any other town in the area and had already organized a town government and numerous businesses. By the time Colorado became a state in 1876, Golden was well established as the Jefferson County seat.

Since its founding in 1873, the Golden Fire Department has been one of the largest volunteer fire departments in the state of Colorado. At first, the department was divided into two rival companies: the Everett Hook and Ladder and the Excelsior Hose. In this image, members of the Excelsior Company pose for an inspection day photo in front of the Avenue Hotel, c. 1893.

The Everett Hook and Ladder Company was a rival company to the Excelsior Hose Company. The two would race separately to the fires, each trying to arrive first and have the honor of battling the blaze. Eventually the two were consolidated into one department with a single fire station. The company poses proudly in their dress uniforms in front of the hook and ladder apparatus, decorated as a parade float. The Golden Fire Department still owns both the original hose cart and the original hook and ladder.

The Pony Express traversed the West for 18 months; mail service was irregular, at best, non-existent at worst. The telegraph took months to install along the rail lines; so, telephone service was an instant hit in the remote western lands. Golden's first lines were installed in September 1879. Subscribers could call only within town. The switchboard was located in the Belle Vista Hotel, with all female attendants. By 1899, the service had 14 subscribers.

Dr. James P. Kelly had this striking Italianate style home built in 1879. Kelly served as the town's physician and druggist from 1866 until 1893, making house calls by horse and buggy. The good doctor was active in the political arena, as well, being elected to the Territorial Legislature in 1863 and as the county treasurer in 1866. He served as a Golden Trustee in 1871 and as Golden's mayor in 1880. The home serves as a keystone in Golden's 12th Street Historic District.

Interestingly enough, this faux frontier fort sits just adjacent to some of the few surviving remnants of Golden's earliest inhabitants. Magic Mountain was built as a Disney-like amusement park in the 1950s. About 1,000 years prior to that, the area served as a long-term campsite for Native American groups. The archaeological site, also called Magic Mountain, has yielded a wonderful picture of the people that constructed a small stone structure, hunted bison and deer, and collected chokecherries along the nearby spring-fed drainage. Following the Native American occupation of the area, it became a mining town. Apex or Apex Gulch served as a stage stop and small mining district during the 1860s. There was every intent to make it a stop on the planned Apex, Chimney Gulch, and China Elevated Railway and Tunnel Company toll road, but the venture never panned out and Apex gradually faded away.

Laura Hendrickson came to the Territory in 1861. She met and married MacDonald "Mac" Parshall in 1880. Their daughter Vera, pictured here, was born in 1884. The Parshall's had numerous business ventures. The family opened a sawmill in 1886. They had a very productive copper mine on the Chimney Gulch, and Mac worked for the Colorado Fertilizing Company for a while. Vera eventually married into the George West family.

David Wall put in the first agricultural irrigation systems in 1859; others followed his example with measurable success. Elwood and Deborah Easley established their orchards along the north bank of Clear Creek in 1878. Their extensive fields of apples, grapes, pears, and other fruit supplied produce to Golden and the nearby mining districts. In 1893, Elwood won prizes at the Chicago World's Exposition for his cherry and plum varieties. The path worn through the orchard by Deborah's wagon, now known as Easley Road, and a few scattered apple trees are virtually all that remain of the Easley farm.

Thomas Pearce was a Cornish miner who homesteaded in Colorado in 1878. He and his wife, Henrietta, built their cabin along Crawford Gulch in the Golden Gate Canyon, west of Golden. The family gradually added neighboring homesteads to their property. They ranched cattle, raised chickens, and grew a variety of crops, including potatoes and sweet peas. The house has since been moved from the Canyon to a living history park in downtown Golden. (Information courtesy of Clear Creek History Park.)

Anthony and Caroline Tripp arrived in Central City in 1879. Like most of the other residents, the Tripps were engaged in mining. Not finding it to their liking, they soon relocated to Golden, homesteading a large area north of the town. The Tripps raised 10 children on their Elk Meadow Ranch. Cattle, hay, vegetables, and grain were all products of their large ranch. Arthur Tripp, one of Anthony and Caroline's sons, went on to become Golden's city clerk in 1908.

Joel Kenyon Palmer and his wife, Matilda, arrived at Arapahoe Bar on June 5, 1860. Four months later their son Charles was born; he was reportedly the first Anglo child born in Arapahoe Bar. Like many before and thousands after them, the Palmer's had come to Colorado for their health. Apparently the clean mountain air proved beneficial, as the family operated a large lucrative truck farm for several decades. Among their offerings: strawberries, raspberries, cherries, apples, plums, pears, onions, cucumbers, corn, tomatoes, and cabbage.

Another family that met with success farming the banks of Clear Creek was the Son family. James Son married Alice Palmer in 1892. They purchased 10 acres of land near the Palmer's farm and began their own small garden. The farm grew into a respectable size produce operation, necessitating the hiring of girls from Golden to help pick the berries. The Son children worked before school each day bundling fruit and vegetables for their father to take in to the Denver City Market and Golden's grocery stores. The family also supplied fresh chickens and calves to Treffiesen's Meat Market.

During the mid-1890s, Harry Buckwalter, an intrepid western photographer, decided to take a different view of the world. This image, taken about 1894 from a hot air balloon, highlights the twin landmarks of Golden: North and South Table Mountains, against a setting sun. The mesas are remnants from a volcanic lava flow and contain many unique geologic and archaeological features. Today, the summits of both mesas are protected open spaces. The Jefferson County Land Trust wants to ensure the preservation of the old homesteads, the mine remnants, and the game drive walls for the benefit of future generations. (Courtesy of the Stephen H. Hart Library, Colorado Historical Society.)

Two
FROM CAPITAL TO COUNTY SEAT

Alfred Tucker settled along the banks of Clear Creek in 1859. At the time, there were numerous settlements in the general vicinity of Golden City, including Arapahoe Bar, Mt. Vernon City, and Golden Gate City. Tucker served as a delegate to the Territorial Legislature to determine which city would be the seat of Jefferson County. Golden Gate City lost to Golden City by a vote of 65 to 163. Tucker returned to his farm in the Golden Gate Canyon, objecting to any additional town development, promoting ranching and farming instead. Eventually, when a toll road was built through the Canyon, Tucker sued the owner for rights to the road and won. This image commemorates the dedication of a marker to Tucker on May 12, 1938.

Most of Colorado was part of the Louisiana Purchase of 1804. When territories were established within the Purchase, everything north of the Arkansas River became part of the Kansas Territory. In 1860, settlers in the western portion of the territory appealed to the Kansas Territorial Legislature to permit them the opportunity to form a separate territory. The Territory of Jefferson was formed. The U.S. Congress disliked that appellation, declaring that there should be no additional states or territories named after presidents. Many names were bantered about, including Idaho and Dakota, but Colorado was chosen to honor the areas original Spanish name. It would not be until 1876 that Colorado would be granted statehood, following the passage of universal suffrage in the territory by the Territorial Legislature, pictured above.

In 1861, the U.S. Congress created the Colorado Territory. The next year Golden was chosen as the territorial capital. Legislators met in the rooms above Loveland's mercantile until 1867 when they voted, by a single ballot, to move the capital to Denver, where it remained. In 1872, the Territorial Legislature changed Golden City's name to Golden.

During its early years, Golden had a reputation for having a saloon on every corner. However, the town maintained some civility in that it closed saloons on Sundays, thereby avoiding the wrath of temperance advocate Carrie Nation. P.B. Cheney constructed his Chicago Saloon on Cherry Point just north of William Loveland's mercantile. In addition to enjoying a booming business from miners headed to the goldfields, Cheney's also supplied free whiskey and plenty of ice to the Territorial Legislators meeting just across from the establishment. Col. John Chivington, later gaining infamy for leading the Sand Creek Massacre, wrote most complimentary of this practice.

Justice in fledgling Golden City was nearly non-existent. Walter Pollard was a strong arm for George West's Boston Company. In order to keep the peace, West appointed Pollard as the first sheriff of Jefferson County. Eventually formal elections were held and the sheriff's position was included in the process. William Smith, pictured here, served as the Jefferson County sheriff from 1874 until 1878, overseeing the construction of the new courthouse during his tenure. Clarence Hoyt and George Cooper served as his under sheriffs. (Courtesy of Dennis L. Potter.)

Before Golden could be incorporated as a town in 1871, it had to appoint a town marshal. In addition to the marshal, there was also a night watchman and a constable. The marshal and watchman handled minor offenses within the town and served as the dogcatchers. Constables were elected officials, reporting directly to the county sheriff; they handled magistrate duties and more serious crimes. James Todd served as one of Golden's marshal before the turn of the 20th century. He is standing in front of the pool hall on Washington Avenue.

In 1872, prior to the formation of the Golden Police Department, Clarence P. Hoyt was elected as Golden's town marshal. He went on to serve as the Jefferson County under-sheriff from 1874 to 1876. Hoyt was appointed night watchman in 1879. He ran, unsuccessfully, for sheriff in 1911. In the interim, he had served as the jailer at the courthouse.

David Caleb Crawford came to Golden City from Canada during the formative period of the Colorado Territory. He and Alexander Jameson opened the county's first abstract office. Simultaneously, the Crawfords operated the Golden House, a local hotel and eatery. In 1870, he helped found the neighboring town of Mt. Vernon to the south of Golden. The staunch Republican would eventually become Colorado's first state auditor.

Robert Millikin arrived in the Colorado Territory in 1860. He took up mining at the Leavenworth Gulch in Gilpin County. Failing to draw a fortune from the muddy soils, he moved the family to the Golden Valley in 1867. Millikin designed and constructed Jefferson County's first courthouse in 1877. He was then elected as Golden's mayor in 1879.

Louisa Caroline Chalfant married Robert Millikin in 1855 in Pennsylvania. In 1860, the family settled in Gilpin County, working the gold diggings of Leavenworth Gulch. Caroline gave birth to 10 children, of which only 4 survived. She was a popular woman in Colorado, retaining a life-long friendship with Augusta Tabor, first wife of silver baron Horace Tabor. The Millikins and several of their children are buried in the Golden Cemetery.

The virtually explosive growth of Jefferson County necessitated a permanent courthouse by 1877. This imposing brick edifice, photographed in 1895, cost $30,000 to construct and measured 65 feet by 75 feet and was 41 feet high. It boasted a judge's chambers, as well as the county's first permanent jail. Prior to its construction, jails were makeshift arrangements at various hotels and vacant buildings throughout Golden. The structure met its demise in the 1960s beneath the blade of a bulldozer.

Alexander Jameson came to Colorado during the territorial period. With David Crawford, he established Golden's first abstract office. Later he became the probate judge of the fledgling territory. When statehood was achieved, Jameson continued to serve on the bench, eventually probating the estate of famed engineer E.L. Berthoud in 1908.

Joseph Seminole Sam Woodruff

In the annals of Jefferson County crime and punishment is recorded the tale of Seminole Joe and Sam Woodruff. Sometime during late September 1879, Bergen Park rancher Rueben Benton Hayward was murdered and his team of horses stolen. Following the discovery of the body in a ditch, Seminole Joe and Woodruff were arrested for the murder. The town was incensed at the outrageous crime. A mob stormed the jail in the dead of night on December 28, 1879, and forcibly removed the two men from their cells. About 20 minutes later, the men were hanged from the railroad bridge.

Having served as the Jefferson County seat since territorial days, much of life in Golden centered on the courthouse. The staff of the District Court Clerk's office gathered on the steps of the courthouse about 1913. That year Charles Pike, a relative of explorer Zebulon Pike, was the court clerk, a post he retained for 30 years.

In April 1883, the City of Golden constructed the first designated station house for the newly unified Golden Fire Department. The station had quarters upstairs for the men with bays downstairs for the hook and ladder and the hose cart. In 1919, the department acquired its first motorized fire apparatus, a Model K International, at a cost of $3,635. Eventually, the building became the city hall as well as the fire department; a new combined building was constructed in 1960 and the old city hall/central station torn down. Pictured from left to right are Elmer Rowe, Robert Geary, Henry Richards, George Ellen, Charles Pyle, Merle Graves, Chief James Stevens, Warden H.V. Crawford, Fred Jobe, William Webster, Thomas Rowe, William Rose, Charles Jaycox, Assistant Chief W.B. Swena, and Gary Kerr.

35

This intrepid young lad, delivering newspapers near the Lookout Mountain School for Boys, was destined for great things. John C. Vivian came from a family long established in Golden and in Colorado politics. His father, John F. Vivian, had served as Golden's mayor from 1901–1908, and as the Jefferson County clerk and recorder. The younger Vivian grew up to become Colorado's governor during the critical years of World War II. He served first as the lieutenant governor from 1939–1943, and then as governor from 1943–1947. The "Governor from Golden" worked to position the state as an integral part of the U.S. defense industry during World War II, and as a manufacturing center during the subsequent Cold War years. Among the developments overseen by Vivian were the Rocky Mountain Arsenal, the Rosehill German POW camp, the Amache Japanese Relocation Camp, and the Colorado Historical Society.

Two
MERCS, MILLS, AND ROCKY MOUNTAIN SPRING WATER

Golden is centered on a main north-south running street, Washington Avenue. It has served as the central business district since Loveland and West platted the town back in 1859. Most of the other streets had their names changed around the turn of the century, and the Clear Creek was eventually channeled from the three braids down to a single canal. The town itself is contained within the boundaries of three major mountain formations, North Table Mountain to the northeast, South Table Mountain to the southeast, and the foothills of the Rocky Mountains to the West. Open corridors exist to the north and south, but the formations effectively limit Golden's size. Golden has always been on the way to somewhere, so it has served as a crossroads for much of its existence. The modern town is bisected by three major highways, with an interstate to its eastern boundary.

Two enterprising men arrived in Golden in 1859. One was George West with the Boston Company; the other was William Loveland. West and Loveland both saw visions of a bustling frontier town, yet to be constructed. The men had a friendly wager to see who could construct the first permanent building in Golden. According to local legend, West's Boston Company store, a purveyor of mining supplies, was completed first, though West publicly denied that, claiming that Loveland finished first by stealing his shingles. The Boston Company headquartered the *Western Mountaineer* newspaper, the post office, and various other establishments in the early years. The building met its demise in the 1920s, but a stone marker commemorates its location. (Courtesy of the Denver Public Library Western History Department.)

The Astor House, built by Seth Lake in 1867, was named for the hotel of the same name in New York, Lake's home state. The hotel served as the residence for many of the Territorial Legislators during 1867, the last year that Golden City served as the Territorial Capital. This image was taken on the hotel's opening day. It has been restored into an historic boarding house museum. (Courtesy of the Astor House Museum.)

In his *History of Jefferson County*, Capt. Edward Berthoud noted with pride that Golden boasted four flour mills. The oldest, the Golden Mill, established in 1864, produced the "Pride of the West" flour as well as feed, hay, and grain. It had a water-powered wheel that ran the stone grinding burrs. Sadly, the impressive building was demolished in 1952.

The Barber family arrived by wagon train in Golden on June 21, 1866. Oscar and Jennie Barber came out with Oscar's father Jonas. The two men built the Rock Flour Mill. The mill closed in the 1880s, following Jonas' death. Oscar moved his family to Pleasant Valley, near Steamboat Springs, and then to Maybell, where he built the town's first school.

Jonas and his son, Oscar, constructed the Rock Flour Mill in 1867. The flour was ground on stone burrs then screened through silk bolting cloth. Ole Swenson served as the millwright. Barber put in a narrow gauge line from the Colorado Central main line to his mill to facilitate the transfer of grain and flour. The Barbers closed the mill in the late 1880s when the Hungarian Flour Mill of Denver put in steel burrs for grinding, thereby making stone burrs virtually obsolete.

The north side of Clear Creek was home to many of Golden's immigrant families. The Burgess House, built in 1865, was located in the section called Goosetown, so named because Coors Brewery kept a flock of some 100 geese there. Burgess House served as the residence for railroad employees and, later, for brewery employees.

Golden's first documented business was a ferry across Clear Creek. Subsequent businesses were mercantiles and mining supply stores. William Loveland constructed one of the oldest permanent buildings in Golden in 1862 to serve as a mercantile. Loveland eventually sold it to Nicholas Koenig, several times, according to the Abstract of Title. Koenig eventually sold the business to his son. The family always operated it as a mercantile. To long-time Goldenites, the building will always be "the Merc." The brick structure has been restored and is a testament to adaptive use.

41

Before George West built the Boston Company store next to Clear Creek, the land was occupied by Gabareno's saloon, a tent establishment, owned and operated by Charles Gabareno. West bought him out and Gabareno moved his establishment further south on Washington Avenue. The new brick structure became a "first class hotel with elegant meals served at reasonable prices." By 1887, C.W. MonPleasure, the owner of the Astor House, had bought Gabareno's. Later, it became the Avenue Hotel and the City Restaurant.

Henry and Gertrude Koch emigrated to Colorado from their home in Germany in 1872. The family homesteaded 50 acres on the south side of North Table Mountain. Their first, and very successful, business venture was a beer garden near their home. The garden featured fruit trees, a dance floor, and a bowling alley. The family then purchased 160 acres on top of Lookout Mountain. With the advent of the funicular, an electric tram ride, on the Mountain, the Koch's opened up a refreshment stand and bowling alley there. This image is of their photography studio.

42

In 1881, Capt. Edward Berthoud led the drive for a fine hotel in Golden, to rival those of the East. The magnificent edifice was to be called the St. Bernard. Fundraising went slowly, but the hotel was finally completed in 1884, and named the Belle Vista. It had 75 rooms, a ballroom, and a billiard room. Sadly, the hotel fared poorly, never realizing its full potential. For a time it housed the telephone service and Jefferson County's Republican Party. It was finally demolished in 1920.

The Overland Hotel, owned for a time by Edward Berthoud, housed the town's laundry, run by a Chinese family. Workers would wet down the clothes for ironing by taking a mouthful of water and spraying it out over the garment. The proprietors were very particular about their business. Every customer had to produce their claim ticket for their laundry—if they couldn't do so, the laundry kept their clothes. Prior to the construction of the courthouse, the hotel also served as the temporary jail.

The Parfet family ran many businesses in Golden during the 19th century. The first was an "omnibus" service to transport people to and from the train station and to haul goods into Denver. C.E. Parfet operated a grocery establishment on Washington Avenue. Parfet Grocery provided many unique items at their mercantile, including fine china and glassware. By the 1890s, the store had become Stewart's Grocery. It is rumored that the Ku Klux Klan carried out their secret meetings on the upper floor of the grocery. (Courtesy of the Denver Public Library Western History Collection.)

Sometimes the history of a building is as interesting as the history of a town. This 1881 image shows Joseph Dennis delivering goods to the Elmus Smith grocery store. During the 20th century, the building has housed a mortuary as well as a grocery, and is rumored to have been part of the Opera House at one time, with portions of a stage hidden behind the mortuary offices.

Among Golden's early businesses was Will Robert's Early Breakfast Market. Among its competitors in the meat market business were Treffeisen's North Side Meat Market, which also sported an ice cream parlor and restaurant, and the Quaintance Meat Market, which delivered ice.

The Haas Block, located on the main thoroughfare through downtown, has had an interesting and varied history. Built in 1871 by Mallon and Chamberlain, it has been home to a meat market, billiard hall, swimming pool, and barbershop. Pictured here in about 1881, its business complement includes Parlor Drugs.

In 1881, Golden experienced its very own savings and loan crisis. F.E. Everett, president of Everett Bank, invested large sums of depositor's money in the Moore Mining and Smelting works, of which he was treasurer. It is also thought he speculated on mining ventures and other "illegitimate sources." All of the ventures failed, leaving Everett virtually bankrupt. Everett, intolerably distraught over the failure, took his own life.

Bill Williams, later known as Cement Bill, operated a taxi service for passengers and freight. His vehicles of choice were Stanley Steamers, introduced to Colorado by F.O. Stanley, the car's inventor. His 12 passenger Steamers left Golden at 10:30 a.m. and traveled to Idaho Springs, stopping along the way for additional riders. The fare was $2.50 for a roundtrip; it was only $1.00 if the rider chose to disembark at Lookout Mountain. The Williams Transportation and Investment Company was located at 13th Street and Washington Avenue.

In 1942, Bud and Pat Butin purchased the old Lookout Mountain Inn and renovated it into the Lookout Mountain Trading Post. The Trading Post sold high-quality Native American jewelry and Pueblo Indian pottery. They often hired dancers from Santa Clara Pueblo, New Mexico, to entertain summer tourists.

"Where the West Shops" is the motto of a Foss Drug Store operated by the Foss family since 1913. Henry and Dorothy Foss came to Golden with the intent to open a pharmacy. They opened a 1,200 square foot pharmacy and general store. During the 1920s, Dorothy manufactured a line of cosmetics in the basement to replace a line that had gone under. The store also manufactured ice cream and fine chocolates until about 1929.

The store has served many needs in the community. In addition to holding the oldest liquor license in the state of Colorado, Foss, until the 1960s, operated both a lunch counter and soda fountain under its roof. During Prohibition, the liquor was sold by doctor's prescription only for medicinal purposes—more than one Golden resident was under doctor's orders to take 100-proof whiskey for their health.

In 1949, Bill and Dorothy Harmsen chose Golden as the site on which to found their company, the Jolly Rancher. They began with the latest fad, soft-serve ice cream, but soon realized they needed a winter product as well, so fine dipped chocolates became the next hot seller for the family. Chocolates became the main line until the mid-1960s when they were phased out. (Courtesy of the Harmsen Family.)

By 1951, the world-famous Fire Stix, a hard cinnamon-flavored taffy, had made its debut. Bill Harmsen, the candy's creator, envisioned a candy with "intense" flavor. It was an instant hit. The hard candy operation became so large that the factory was moved from Golden to the family farm in Wheat Ridge in the early 1950s. (Courtesy of the Harmsen Family.)

Born near Düsseldorf, Germany in 1847, young Adolphus Kuhrs apprenticed to both a printer and a braumeister before striking out on his own. Local legend states that in 1868, Kuhrs stowed away on a boat bound for America to escape the political and economic repression of Germany, as well as compulsory military service. Following his arrival in America, Coors worked as a stonecutter, bricklayer, fireman, general laborer, and brewer in Baltimore and Chicago. By 1873, he had arrived in Golden, Colorado, and bought a bottling works with the intent of opening a brewery. Coors then encountered Jacob Schueler, a confectioner in downtown Denver. The men formed a partnership and the rest is pure Rocky Mountain spring water history.

THE GOLDEN BREWERY.
GOLDEN, COLORADO.

Co-founded by Adolph Coors and Jacob Schueler in 1873, Coors Brewing Company is the very essence of the American dream. The November 12, 1873 edition of the *Colorado Transcript* noted: "Another new and extensive manufacturey is about to be added to the number already in Golden. Messers J. Scheuler (sic) and Adolph Coors, of Denver, have purchased the old tannery property of C.C. Welch and John Pipe, and will convert it into a brewery. They propose making large additions to the building, making it into one of the most extensive works of its kind in the territory…."

By the end of their first year of production, Coors and Schueler produced over 100 kegs of beer daily. To market the product, Coors took wagonloads of the product to the mountain mining towns. He gave each saloon owner a free case of beer, with the bargain that if the miners liked the product, the owner would purchase the saloon's beer supply from the brewery. It was an instant success.

Adolph Coors married Louise Webber on April 12, 1879. She was the daughter of the Superintendent of the Denver and Rio Grande Railroad maintenance shops. The *Colorado Transcript* reported: "The *Transcript* joins a large circle of admirers in Golden, Denver, and throughout the state in wishing Mr. and Mrs. Coors a happy journey through life with milestones of the incidental blessings that wait on matrimony." Mrs. Coors often served as the gentle hand on her husband's back in many decisions he made about the brewery.

Threatened by the Prohibition Act, on January 1, 1916, the Coors Brewing Company dumped some 17,000 gallons of beer into the Clear Creek. They then converted the beer-making operation into a malted milk operation until the Act was repealed. This enabled the company to retain most of its loyal, hardworking employees. Coors continued production of malted milk until the 1950s, when its popularity began to wane. Sadly, Adolph Coors did not live to see the end of Prohibition; he died in June 1929, possibly believing that the future of his beloved brewery was in imminent peril.

The Coors Company rarely limited itself to the mere production of beer. During Prohibition, the company had an excess of butterfat from their malted milk operations. Ralph Worden delivered butter for the Coors Brewing Company from the back of his Dodge Ram truck during the 1930s. (Courtesy of the Denver Public Library Western History Department.)

In 1874, Adolph Coors designed a beer garden for the grounds of the brewery. The Golden Grove had a dance floor, gardens, a pond, and other amenities. He eventually added withdrawing rooms and dressing rooms. In 1881, Mrs. Coors persuaded her husband to close the garden and renovate the pavilion into the family home. The neo-Gothic Revival home has long stood amidst the grey concrete brewery structures and was once flooded with barley when the storage tank behind it gave way.

As part of the brewery operation, Coors had added a glass plant. Golden Glassworks produced bottles for Coors and other operations throughout the Front Range. In 1910, he turned the glassworks over to John Harold for production of fireproof china cooking utensils. Harold left after two years, so Coors took over the operation and began producing chemical porcelain and spark plugs. In 1920, it was renamed to Coors Porcelain Company. For nearly a half-century the plant manufactured high-quality glazed ceramics for home use. Among its popular lines were Rosebud, Mello-tone, and the Open Window patterns. The highly colorful glazes they used pre-date the advent of the Fiestaware line by more than a decade. CoorsTek, as it is now called, only manufactures scientific and chemical pieces.

Four
GOLD FEVER!

During the Pikes-Peak-or-Bust gold rush that followed the 1858 Cherry Creek discovery, 100,000 people came out to the Colorado Territory seeking their fortunes. Many came from the waning rush in California, looking for that land where gold lay over the surface of the land. Others came from the East, seeking adventure or a new life. Towns sprouted like weeds, given the most convenient name at hand or named after another town where gold was rich, in hopes of parlaying the luck in the new site. Black Hawk, Cripple Creek, Nevadaville, Tincup, and Gold Hill were just a few of the hundreds.

Gold fever was definitely in the air in Colorado in 1859. Gold discoveries on Ralston and Cherry Creeks prompted the newest rush. John Gregory, grubstaked by Golden resident D.K. Wall, discovered what became known as the "richest square mile on earth." With $2,000 he traveled to the future site of Central City. In his first pan drawn from the Clear Creek, Gregory had a quarter of an ounce of gold. He hit pay dirt with the Gregory Lode, Colorado's first actively mined underground gold vein. Since its discovery on May 1, 1859, the vein has paid out more than 1 million ounces of gold ore. But life was not always high for those mining the Gregory Gulch. Journalist Bayaud Taylor wrote in 1865, "The houses are jammed into the narrow bed of the canon, employing all sorts of fantastic expedients to find room and support themselves. Under them, a filthy stream falls down the defile over a succession of dams. It's a wonderfully curious and original place." (Courtesy of the Gilpin County Historical Society.)

Shortly after the 1858 gold discovery, mining districts began establishing claim laws. The Gregory District, located 18 miles west of Golden, established that each miner was permitted one "mountain claim", or hard rock lode; one "gulch claim", or gravel claim; and a "creek claim", or panning site. Each claim could be no more than 100 feet in length. The hills are pockmarked with the remains of failed claims.

"The mines with their prolonged subterranean workings, their stamping and crushing mills, and the smelting works which have been established near them, fill the district with noise, hubbub, and smoke by night and day; but I had turned altogether aside from them into a still region, where each miner in solitude was grubbing for himself, and confiding to none his finds or disappointments." (Quote courtesy of Isabella Bird, *A Lady's Life in the Rocky Mountains*.)

PLACER MINING IN EARLY DAYS

Despite Rufus Sage finding gold in Clear Creek in the 1840s, Golden never had any gold mines, but its economy depended heavily on the mines being worked to the west. Removing gold from the surface of a stream is called placer mining; it involves various pieces of equipment including sluice boxes, long toms, and shaker tables; but most often shovels and sweat. (Courtesy of the Gilpin County Historical Society.)

Colorado first went through the glory and disappointment of the gold boom and bust; then, with the repeal of the Sherman Silver Act in 1893, experienced the same with silver. Many towns were built and then abandoned with these cycles. Nevadaville, located to the west of Golden, was one such sad case. It is surrounded by the Kansas, California, and Burroughs gold veins and from the 1870s through the 1890s rivaled Golden in size. All that remains is a handful of buildings.

The Colorado School of Mines and the impressive geologic features of the region have long drawn the scientifically minded to the area. This jaunty turn-of-the-century geologist carries his trusty rock hammer in the top of his boot, a more common fashion accessory in Golden than the six-shooter.

Smelting is integral to the mining process. Ore must be processed under high heat to separate the desired metals from the surrounding rock matrix. Gold and silver were removed from a lead matrix using the Parkes Process. This technique introduces a 2 percent zinc solution into the molten lead. The gold and silver dissolve into the zinc; the zinc mixture floats to the top, solidifies, and is then skimmed off. The final step involves distilling the zinc to recover the gold and silver. W.B. Young, William West, and T.S. McMorris established the Golden Smelter in 1872. It was located on the Colorado Central Railroad line where the line entered Clear Creek Canyon, establishing its two-acre site as the first potential ore drop point in Golden. It processed up to 25 tons of gold, silver, and copper ore per day.

VALLEY SMELTING WORKS.

Valley Smelting Works was constructed in 1879 to meet the growing ore processing need. The *Colorado Transcript* noted that it was the most advanced of the works under construction at the time. It boasted two 40-feet-by-10-feet roasting furnaces and a building measuring 75-by-50-feet. They had a daily capacity of about 15 tons of ore. The Moore Mining and Smelting Company acquired and renamed the operation in 1881. They shipped between $60,000 and $70,000 worth of bullion each month. Francis E. Everett, a local banker, served as the treasurer of the company until his death in 1881. By 1911, all of the smelters in Golden had ceased operations. This was due, in part, to the expense of mineral extraction.

Wm. Moore, President.
F. E. Everett, Treasurer.

R. D. Hall, Secretary.
G. Boaen, Superintendent.

THE MOORE
MINING AND SMELTING COMPANY.

SPECIAL PRICES FOR ORE HIGH IN LEAD AND LOW IN SILVER.

NO CHARGE FOR CRUSHING AND SAMPLING.

HIGHEST PRICES FOR GOLD OR SILVER ORE.

GOLDEN, - - COLORADO.

In Golden, coal was king. First located by Swiss engineer Edward Berthoud in 1862, the bed that became the basis of the White Ash Mine lay just below the center of town. The coal, called black diamonds, was shipped to nearby mountain mining towns for fuel, as well as being used in local smelters. On September 9, 1889, the White Ash Mine experienced a tragedy when one of the tunnels being worked near Clear Creek approached too closely to another tunnel that had been on fire for some time. The extreme heat from the fire caused the wall between the tunnels to burst, as well as bursting the wall to the creek. Boiling water flooded the tunnels, entombing 10 miners about 400 feet below the surface.

Working the Black Diamond vein, the Black Diamond Mine removed between 100 and 300 tons of coal per day from shaft beneath Golden, some as deep as 700 feet. By the time this image was taken in the 1890s, coal mining was waning in the area, being too costly to extract coal from vertical veins.

Located along the hogback formations west of Golden lie deposits of steel-blue clay and deposits of light buff-colored clay. The blue clay, high in silica, was mined for use in firebricks. The buff clay was destined for Coors Porcelain Company as decorative dinnerware. The Parfet family, long-time Golden pioneers, operated many of the mines.

Along with the clay mines came firebrick manufacturing. Clay was pulverized, then molded, pressed, and dried. The five kilns of the Golden Fire Brick Company each had a capacity of 6,000 bricks per day. The company used 8 tons of coal per day during the 1880s.

Five

From Capital to County Seat

Envisioned by builder James H. Gow as an old English castle, the National Guard Armory was constructed in 1913 using 500 sacks of cement, 3,300 horse-drawn wagonloads of stream cobbles, and 1,000 cubic yards of sand. Many townspeople considered it Gow's folly, and indeed, with its four-story tower and rounded battlements, the building was certainly distinctive. It is thought to be the largest cobblestone structure in the U.S. and has housed the U.S. Post Office, the Colorado National Guard, the Colorado Rangers, and retail shops. Over the highly decorative doors is carved "A 1913" for Company A of the Colorado National Guard and the year the building opened.

ROSTER
OF
T. H. Dodd Post No. 3, G. A. R.
DEPARTMENT OF COLORADO AND WYOMING

GOLDEN, COLORADO, NOVEMBER 15, 1909

Abbott, Samuel L.	Private Ind. Colo. Bat'y
Anderson, Andrew P.	Private Co. G, 47th Ill. Inft'y
Albertson, J. H.	Sergeant Co. M, 10th N. Y. Cav
Arnold, George R.	Private Co. L, 16th Kan. Cav
Babcock, J. D.	Private Co. C, 2nd Ill. L. A.
Castor, W. S.	Private Co. B, 126th Ill. Inft'y
Cilley, Geo. W.	Corporal Co. I, 2nd N. H. Inft'y
Cilley, James A.	Private Co. F, 18th N. H. Inft'y
Cunningham, F. M.	Private Co. E, 55th Ky. Inft'y
Eldridge, Samuel	Mate, N. Atlantic Squadron
Erwin, S. V.	Private, Co. E, 65th Ill. Inft'y
Gorham, C. H.	Private Co. E, 60th Mass. Inft'y
Hemberger, Louis	Sergeant Co. D, 9oth Ind. Cav
Hail, Ira D.	Private Co. G, 183 O. V. S.
Hess, A. L.	Private Co. E, 10th Iowa Inft'y
Hitchcox, D. M.	Sergeant Co. G, 1st Colo. Cav
Jameson, Alex. D.	Private Co. H, 5th Iowa Cav
Johnson, J. M. Jr.	Private Co. I, 15th Ill. Inft'y
Koenig, Christ	Lieutenant Co. A, 1st W. Va. Art
Kerr, Alex	Corporal Co. C, 12th Vet. Res. Corps
Lichtenheld, Richard	Sergeant Co. A, 106th Ohio Inft'y
Menchner, Philipp	Blacksmith Co. E, 3rd Mo. Cav
Monroe, Geo. W.	Sergeant Co. G, 35th N. Y. Inft'y
Randall, J. L.	Private Co. E, 19th Ill. Inft'y
Raught, Andrew J.	Private Co. E, 129th Ind. Inft'y
Snyder, Benjamin F.	Serg'n't Co. A, 2nd Ia. Vet. Vol. Cav
Stanley, James R.	Ass't. Sig. Officer, S. A. B. Squadron
Songer, F. W.	Lieutenant Co. C, 111th Ill. Inft'y
Treffeisen, John	1st Lieutenant Co. G, 8th Pa. Inft'y
Whitehead, W. H.	2nd Lieutenant, 124th Pa. Inf'y

The Grand Army of the Republic was comprised of veterans of the Union Army from the American Civil War. For many years the organization sponsored Memorial Day. Golden's chapter, the T.H. Dodd Post No. 7, was founded on April 12, 1879. The Post had 19 charter members, including Capt. E.L. Berthoud, Capt. George West, Lt. Col. T.J. Capps, and Corp. A.D. Jameson.

The Women's Relief Corps of the GAR was comprised of mothers, wives, daughters, and sisters of Union soldiers, sailors, and marines. Their primary functions were to aid the GAR and to provide "needful aid" to the widows and orphans of the Union veterans. Mrs. Eliza West, the wife of veteran George West, owned this booklet in 1889.

RULES AND REGULATIONS

FOR THE GOVERNMENT OF THE

WOMAN'S RELIEF CORPS.

AUXILIARY TO THE

Grand Army of the Republic.

◆ 1889 ◆

OCTOBER EDITION.

Many of Golden's early residents were veterans of the Mexican-American War and the American Civil War. George West was a Civil War veteran from the Colorado Volunteer Infantry. He then served as the Brigadier General of the Colorado National Guard from 1887–1889. Neil West Kimball, grandson of George West, served as the Brigadier General of the Colorado National Guard during the 1930s. He was instrumental in having the state rifle renamed to Camp George West in 1934. Kimball was a veteran of World War I.

Company A of the Colorado National Guard was appropriately enough stationed in Golden. It was the Guard's engineering unit. All of the men serving in it were students from the Colorado School of Mines. One of the first men conscripted from Jefferson County in 1917 was sent to Company A. Company B, from Pennsylvania, was the only other National Guard engineering unit during World War I; it was comprised of professional engineers, rather than students.

Camp George West, located to the east of Golden, started out as the state rifle range in 1903. In 1934 it became the training ground for the Colorado National Guard in marksmanship, artillery, and tanks. During World War II, Camp George West was concerned with the training of military police, infantry, and field artillery. Green Mountain, located two miles southeast, was used as an impact area. This image shows the construction of an underground storage facility. Since World War II, it has served as the departure point for Guard units serving in every war and military action until the Persian Gu lf War.

National Guard units from all over Colorado met often for parades and exercises at Camp George West. Parades are few at the camp these days. Today it serves as a vehicle maintenance and warehouse site for Guard units. Harry M. Rhoads took the upper photograph of a Guard parade about 1915. In the lower image P-12 aircraft fly over a June 1933 gathering of units from over 20 Colorado towns. (Courtesy of the Denver Public Library Western History Collection.)

Prior to World War I, Coors U.S. Chemical and Scientific Porcelain operated eight kilns and primarily made ceramics for home use. There was a great demand for the company to become involved in war production efforts, so in 1917, they added a ninth kiln and began converting operations toward the war. During World War II, they again concentrated on war production, creating porcelain housings for the atomic bombs of the Manhattan Project and Livermore Laboratories. After the war, the government work slowed down but did not cease. Coors has

continued producing scientific and highly specialized ceramic materials for a variety government contracts. However, the production of most of the household pieces has ceased. For a time, the company produced mugs, ashtrays, and other items for taverns and as souvenirs, but even that is rare today. During the Vietnam War, Coors Porcelain made flack jackets for helicopter pilots.

During World War I, Jefferson County contributed dutifully to the Red Cross efforts. Newspaper articles appealed to the plight of the eight million Europeans displaced or affected by the Great War. For the 1917 fundraiser, Jefferson County raised $18,000, with Adolph Coors contributing $1,450 to the effort. Golden alone contributed $5,000 the following year.

A June 21, 1917 cartoon in the *Colorado Transcript* encourages readers to donate $1, $2, or $5 to the Red Cross to help the stricken millions in Europe.

The Wagenbach family, like many in Golden, has a long and illustrious history. William and Frank Wagenbach built a dance pavilion on Lookout Mountain in 1914. The hot-spot offered music, soft drinks, ice cream, lunches, and the use of a telescope to enjoy the magnificent views. The pavilion's grand opening was on July 1, 1915, for the annual firemen's picnic. They intended to expand operations to include a casino, but a world war and the changing face of Colorado tourism halted the plans. Frank, pictured here on the right, served in the U.S. Army during World War I. (Courtesy of Lorraine Wagenbach.)

David Baker spent 1918 stationed at Camp Funton, Kansas. His responsibilities included driving the flu wagon. Many soldiers died from the flu epidemic that year. Due to the shortage of caskets, Baker would wrap the bodies of the dead in their blankets and take them, by wagon, to the train depot to be shipped home for burial. Following the war and a short stint as a sheep rancher, Baker settled near Golden in 1936.

While unconfirmed, Golden is purported to have provided more men per capita to every war from the Civil War to the Vietnam War than any other town in Colorado. World War I was no exception. So, Armistice Day on November 11, 1918, became one of high celebration. Headlines in the *Colorado Transcript* for November 14, 1918 read: "Golden Goes Wild When Glorious News of Victory is Received."

The celebration of the World War I armistice began when Golden received the news at 1:30 a.m. Church bells, whistles, and shots rang out across the city. By 9:30 a.m., an impromptu parade appeared on Washington Avenue, including the Industrial School Band, a bonfire, and speeches by local dignitaries. The fire bell was rung so hard that it cracked; it was renamed "The Liberty Bell."

Golden's own "Liberty Bell" started out as the town's fire bell. It was cast in Pennsylvania in 1867 and brought to Golden by train in 1883. The bell weighed 1,300 pounds. When it was first rung, the newspapers reported that it was "clear in tone" and "could be heard in all portions of town." For the Armistice celebration, the bell was first tolled at 1:30 a.m. It was rung almost continuously on that night until 6:30 a.m, cracking soon after.

During the 1930s, one of the most popular and least expensive forms of entertainment was the junk car derby held on South Table Mountain. Old cars were run across the top of the mesa then allowed to plummet off the top of Castle Rock to crash on the mountainside. The junked cars often caught fire, making quite a spectacle. During the war, metal was in high demand, so the cars were salvaged and recycled. This intrepid cadre of Boy Scouts conducted a scrap metal drive, possibly harvesting the junk cars, under the auspices of the fire department.

Six
WHERE THE WEST PLAYS!

The Rocky Mountains beckon sportsmen, outdoor enthusiasts, and adventurers. Tourism, especially eco-tourism, has long been a staple of Golden's economy. Bicycles caught on quickly in Colorado as a form of family entertainment and as a way to see the countryside. One of the first reported owners of a high wheel bicycle in Golden was a professor at the Colorado School of Mines. Women eventually gained bikes of their own, able to be ridden without threatening a ladies' modesty. Across the country, unused railroad beds were filled in and converted into bike paths.

Long before William F. "Buffalo Bill" Cody ever founded his elaborate Wild West show of lady sharp shooters and Indian war re-enactments, he was a buffalo hunter and a messenger for the Pony Express. From 1867 to 1868, Cody worked as a scout and buffalo hunter for the Army. He garnered his moniker, Buffalo Bill, for killing 4,280 buffalo and a Medal of Honor for bravery during that time. But Cody's true calling was always showmanship. His Wild West show boasted 86 different acts between 1883 and 1913, with a cast of 100 to 300 people. During the heyday of the show, Buffalo Bill told his wife, Louisa, and cowgirl Goldie Griffith, "I'm going to show you where I'm going to sleep, the most beautiful scene you ever saw." He was referring to Point Lookout, now Lookout Mountain, overlooking Golden with views south the New Mexico, east to Kansas, and north to Wyoming.

Buffalo Bill Cody passed away in January 1917. After lying in state in the Colorado capital rotunda, the body was put on ice for five months until the ground on Lookout Mountain had thawed enough for a grave to be dug. Col. John Springer eulogized him this way, "Oh Princely Lookout Mountain, they highly honored crest, shall hold in trust the sleeping dust of him we loved the best…two continents will miss him, his record yet remains. Oh Princely Lookout Mountain, strong monument of grace, by living voice, Pahaska's choice, to be his resting place."

On June 3, 1917, over five months after his passing, showman Buffalo Bill Cody was laid to rest high atop Lookout Mountain. A full Masonic ritual was accompanied by an 11-gun salute from the Colorado National Guard. It is estimated that 25,000 people attended his funeral. Dignitaries from numerous world countries were in evidence. Bill's burial there ignited a bitter animosity between Colorado and Cody, Wyoming, the town Buffalo Bill founded. The City of Cody claimed Bill had intended to be buried there, not on the mountain, as he had told his wife, Louisa, earlier.

The Lookout Mountain Funicular was the Castle Rock Funicular's direct competition. Rees Vidler opened the attraction in 1912. Two cars, with 32 seats each, transported visitors up the 67 percent grade to the top of Mount Lookout. For only $1.35 one received a glorious view of the eastern Plains of Colorado.

Sadly, the Lookout Mountain funicular's business suffered when the Lariat Loop was completed in 1914. This majestic outlook at Wildcat Point became accessible to metro area visitors seeking to traverse the Denver Mountain Parks System, which included Mount Lookout, Evergreen, and Red Rocks.

Sundays were a popular day for Denverites to leave the city and seek entertainment elsewhere. Oftentimes, their destination was Golden. The interurban, an electric streetcar, made the 12-mile trip in just under an hour from the Barnum station to the Washington Avenue station. Afternoon adventurers would bring a picnic lunch with the intent to enjoy the wonderful views from atop one of Golden's surrounding mountains.

Riders stepping off the Denver to Golden Interurban tram were greeted by a stout man calling, "Ride the donkeys. Ride the donkeys. Climb to the top of Castle Rock." For a small fee, intrepid visitors would travel to the heights of South Table Mountain on the backs of Charlie Quaintance's donkeys. Photographs were an extra charge.

The winding bridle path up South Table Mountain led to the massive basalt formation of Castle Rock. High atop Castle Rock sat the Lava Lane Dance Hall, alleged meeting place for the local chapter of the Ku Klux Klan. In this unique image, the dance hall, the funicular, and the burro trail are all in evidence.

In 1913, A.D. and his brother Charlie Quaintance decided to offer the Lookout Mountain Funicular a little healthy competition and opened a funicular up the side of South Table Mountain. It opened on July 3 that same year. Ticket holders awaiting their trip could partake of lemonade, ice cream, or other treats at the base station.

For 25¢ the Castle Rock funicular delivered patrons to the Lava Lane dance hall, high above Golden. Builder Charlie Quaintance envisioned three telescopes and a 30-foot searchlight on the mountaintop. That vision never materialized. The funicular only lasted two years, from 1913 to 1915, while the dance hall survived until 1927 before succumbing to an un-fightable fire.

5953. Golden, Colorado, and Entrance to Clear Creek Canon, from Castle Rock Mountain Scenic Incline Railway. Denver Mountain Parks.

A gala opening was planned for the Castle Rock Funicular's debut. Miss Maud McGregor was chosen as the "Queen of Light" for the festivities. She was to wave her wand and light Castle Rock for the first trip to the stars. The lights were those of the dance hall perched high atop Castle Rock.

1528 CASTLE ROCK MOUNTAIN, "THE PEERLESS PANORAMIC PEAK OF THE ROCKIES," GOLDEN, COLO.

The 30-minute round-trip on the Castle Rock Funicular cost 50¢, but promised breathtaking views in every direction. Each car held 32 passengers. A funicular is electric powered and operates on a counter-weight principle; with very little effort, the descending car pulls the ascending car up the hillside. Each car is equipped with safety brakes.

82

Since the very beginning of the movie industry, Colorado has been a popular location for filmmakers to utilize. The wide-open vistas, impressive rock formations, and often quaint western towns have served the profession well. In this image, Rex the Wonder Horse, star of such classic 1920s and '30s films as *Law of the Wild* and *Adventures of Rex and Rinty*, poses on the rocks at Red Rocks, south of Golden, for a publicity shot.

A 1916 article in the *Colorado Transcript* advised Goldenites to "be sure to be loyal to the Berthoud Baseball team," named for town engineer Edward Berthoud. Baseball had a long life in Golden, with numerous teams over the years taking the field, including the most recent, the Coors Silver Bullets.

The Lariat Trail is a miracle of 20th century road construction. Its 56 perfectly banked curves, 7 of which are hairpin curves, wind gently up the side of Mount Zion and Lookout Mountain. The road eventually settles the intrepid auto traveler high atop the Mountain at Wildcat Point. Along the way the road had been piped and springhouses erected to provide liquid refreshment for both travelers and automobiles. During the 1920s, auto tourism through Denver Mountain Parks was a popular way to pass a Sunday afternoon, with Wild Cat Point being a favored stop along the route.

Theater was long an important part of life in Golden. The Opera House and the Dramatic Society date to its earliest days. The February 1896 performances of *The Private Secretary* were given on two consecutive nights by the Dramatic Club. Proceeds went to purchase a public drinking fountain in downtown Golden.

Golden's love affair with the arts goes back to 1879 with the opening of the Opera House. A gala ball was held to commemorate the occasion. The Golden Gem, pictured here in 1935, proved to be a worthy successor, showing all of the latest Hollywood offerings. It was one of four movie houses in downtown Golden.

Organized competitions between fire companies have been an integral part of the life of a firefighter since the profession began in America. In 1885, the Everett Hook and Ladder Company won the state competition in Boulder. Pictured here, in their competition uniforms, are: #1 Pete Reed, #2 John Lomax, #3 George Vogel, #4 ? Stevens, #5 V. Van Bramner, #6 Chief F.W. McConkey, #7 Henry Hodges, #8 F. Fuller, #9 L.C. Nixon, #10 Dave Gilbert, #11 Teen Jinachico, #12 Capt. J.D. Sivyer, #13 Phil Klatt, #14 William Blatter, #15 John Floyd, and #16 H. Hinman.

Fire companies often mentored younger members of the community, in hopes that the boys would aspire to become the firefighters who would someday replace their mentors. Golden's department worked very closely over the years, sponsoring the boys in musters and competitions. Pictured on the 1913 hose cart team are Robert Todd, Wilber Rowe, Elmer Youngwall, Walter Griffith, Ray Shepherd, and Tom Grenfell.

What is a western town without the famous western entertainment of rodeo? Jack Browne, a local politician and entrepreneur, hosted rodeos several times a year at Pioneer Park on South Table Mountain. The biggest and most widely publicized of these were for Golden Days in August. Though the rodeos only lasted from the late 1940s through the mid-1950s, Golden residents who attended remember them fondly. Pictured during the presentation of the colors are, from left to right, Don Crane, Art Peterson, Harold Johnson, Warren Frances, and Clarence Wilson. The three cowboys in the upper photo are unidentified.

September 3, 1957, marked the groundbreaking for a new 600-acre site designed to capitalize on the 1950s idealized vision of the West. Magic Mountain was to have everything a family could want for an afternoon's outing—forts, stagecoaches, gunfights, even a haunted house. Designers from the Disney Company had planned it as Disneyland in Middle America. Sadly, the park succumbed to financial mismanagement in 1962; most of the rides were shipped to Texas to form the base of Six Flags over Texas. The park was sold and then reopened as the Heritage Square amusement area in 1970. (Courtesy of Le Roy and Beverly Allen.)

In a small town, entertainment takes many forms, including that of a tight rope walker teetering high over Washington Avenue, the main thoroughfare through town. This act may have been part of the Armistice Day celebrations in 1918 or the subsequent celebrations in 1919.

Airplanes were a rarity in Golden. The nearest airport is about 12 miles distant, and there is little level ground on which to taxi a plane. This was, undoubtedly, a tourist photo opportunity during the first quarter of the 20th century. Castle Rock and South Table Mountain form the painted backdrop.

"Denver, August 16, 1915. Dear Grace: I enjoyed your letter very much even if I did get it late. Am still having a grand time. Saw this scene yesterday. From Golden we rode up Lookout Mt. and scrambled down. Some stunt. A walk of about 4 miles to Golden over the roughest, rockiest road but worth the trouble. Will see you soon. Leave for home Thursday night for sure. Clara."

Seven
Traveling through History

Prior to Cement Bill William's Lariat Trail there was a wagon road that traversed Mount Lookout. This image commemorates the first trip of a wagonette over that road in 1895. Pictured here are driver Carlos Lake, Jim Lloyd, Cora Dougherty, Anna Dougherty, Mattie Elwood, Alice Gow, Reta Klain, Helen Neff, Ella Deave, Lee Wise, Fred Burgess, Billy Tudor, Al Dollison, and Jake Silverthorn.

Transportation took many forms in early Golden, including that of the four-legged variety. Charlie Quaintance stabled burros on Washington Avenue for the express purpose of transporting tourists to the top of the southernmost mesa in the valley. Ladies were provided with dusters to protect their clothing. Photos were three for $1. (Courtesy of Albert Hansen.)

William "Cement Bill" Williams came to Golden from Deadwood, South Dakota in 1901. He gained the moniker of "Cement Bill" because of his penchant for constructing cement bridges, reservoirs, and sidewalks. He ordered so much cement that the local hardware store could scarcely keep up. Williams gained additional status as a road builder during his time in Golden.

In 1911, the town of Idaho Springs began constructing a road from their mountain enclave to Denver. This endeavor would bypass Golden entirely. Cement Bill Williams lobbied Denver to favor a route directly through Golden, over Mt. Zion. He received support funds from Jefferson County, the State Highway Commission, and Adolph Coors.

Cement Bill Williams, pictured here with two co-workers, takes delivery of a shipment of 200 barrels of cement donated by Charles Boettcher for the Lariat Trail road building effort. Williams completed the road in 1914; however, he was still owed $2,500 from the Denver Park Commission. In an effort to receive payment, Williams erected a blockade at the base of the road and refused passage to Denver cars and tour buses. Williams was court ordered to remove the blockade, but did not receive his final compensation until 1919.

According to the *Denver Republican*, "The road is as novel as the Georgetown Loop, as it, too, winds around a mountain ascending as it does so. Even a mountain can't stand in the way, when modern man wants a road." The Lariat Trail cost $40,000 to construct and remains one of the most scenic roads in the Colorado foothills.

Golden was on most of the major transport lines between the plains and the mountains. Several rail lines made their way through Golden, including the Colorado Central, the Denver, Leadville & Gulf, and the Denver, Lakewood & Golden.

Loveland held great hope in Golden being on the route of the trans-continental Union Pacific railroad. Alas, it was not to be, when the Union Pacific representative visited the proposed mountain route in October 1866, present day Berthoud Pass, his party became snowed in for three days. Descending the mountain, the man declared that the passes were too high and that Denver, and by default Golden, was a town "too dead to bury."

Entrepreneur and war veteran William A.H. Loveland envisioned a town bustling with the life of the railroad. Using his own capital, Loveland broke ground for the Colorado Central line on January 1, 1868, with the first train reaching Golden in 1870.

One of the first coal-powered steam trains makes its way up the Colorado Central narrow gauge line from Golden to Central City. The line has been recognized as a credit to its builders as the first narrow gauge into the mountains, greatly improving the economies of the towns touched by it. (Courtesy of the Colorado Railroad Museum.)

Though the Union Pacific line never came through Golden, trains played a significant role in its history. Loveland designed the narrow gauge line that wound through the Clear Creek canyon. These passengers posed for a photo in 1896 at Hanging Rock along the route.

Edward Berthoud, Swiss engineer from Golden, designed one of the most unique narrow gauge lines in the country. The Georgetown Loop, pictured here on the High Bridge portion of the run, is only a mile in length as the crow flies, running from the mines of Silver Plume down to Georgetown, yet it has 4.47 miles of track, constructed into a spiral and two reverse loops. The High Bridge towers 96 feet over Clear Creek at the section known as Devil's Gate.

The engines on the Colorado and Southern were all oil burning. This prevented the forest fires that frequently resulted from wood and coal burning steam engines. Fred Maas stands atop engine #70 filling the reservoir with water from the Golden tower. The expression "this is a jerk-water town" derived from this activity. (Courtesy of the Colorado Railroad Museum.)

Engine 69 of the Colorado and Southern Line parked at the water tank on Eighth Street and Washington Avenue on June 15, 1941. Pictured on the caboose are ? Palucci, F.B. Maas (conductor), and M.R. Ward (brakeman).

The Maas family poses on the caboose of the Colorado and Southern train for its final trip up the Clear Creek Canyon on May 4, 1941. Three generations of railroad workers came from the Maas family. Ben Maas helped lay the first track on the line in 1870. Billy Maas worked on the Mountain Branch to Georgetown, and Fred handled the Golden to Idaho Springs run. The line fell victim to the popularity of automobile tourism and the death of mountain gold mining.

Known as the yellow perils, Golden boasted two electric trolley lines, one from the north and one from the south. The southern route began in the 1870s as the Denver, Lakewood & Golden Railroad, ferrying clay from the mine to the Morrison rail line. Eventually, the line hauled people instead of freight. The perils made their last runs in the early 1970s. (Courtesy of the Colorado Railroad Museum.)

Seven
A Higher Standard: Education on the Frontier

Education has always been paramount in Golden. Almost before the foundations of the first permanent buildings were laid, the first school opened. The small private academy opened in January 1860 with 18 students. By the fall term of 1860, the school was crowded, necessitating the hiring of a second teacher. The school and the town continued to grow. The school was replaced in 1863 by a single-story brick structure on Washington Avenue. Robert Millikin, owner of Millikin and Lee Construction Company, built several of the subsequent schools in Golden. Golden also boasts the oldest public high school in the state, founded in 1873.

The Guy Hill School was built between 1874 and 1876 in Golden Gate Canyon. Enrollment varied, but by 1951 it had about 27 pupils from all 12 grades. The school was closed in 1951. It remained vacant until 1976 when the students at Mitchell Elementary in Golden petitioned to have it moved down to their school grounds. The school stood at Mitchell until about 1994 when that school was closed; Guy Hill was moved one last time to serve as the keystone to a new living history museum in downtown Golden. Standing to the left of Mrs. George Ramstetter is Hassie McKnight, the last teacher at the Guy Hill School before it closed.

The South School, constructed in 1873, had an initial attendance of 195 students. The school housed primary, intermediate, and grammar school grades. This is the fifth grade class of 1932.

By 1892, a complete high school was established within the walls of South School. This marked the founding of what would become the oldest high school in Colorado. Ninth through twelfth grades did not gain their own building until 1924.

Clear Creek has traditionally divided Golden along social as well as geographic lines. Northsiders were comprised of Welsh and German immigrants who worked in the mines and north side mills. North School was constructed in 1879 at a cost of $7,000 to accommodate the overflow of students from South School. It opened with 4 completed classrooms and 256 students. The school was designed by James Gow, who went on to build the National Guard Armory.

North School was purchased by Jefferson County in 1937. It housed a variety of institutions over the years, including the Jefferson County Pioneer Museum in 1939, the Welfare Department, and the World War II Ration Board. North succumbed to the advancing needs of Golden's population in 1965 when it was demolished to make room for a highway.

By 1920, the Central School was severely overcrowded. This imposing edifice was constructed to serve as the new junior high school, enabling the Central School to divest itself of the middle and upper grades. Golden built a separate high school in 1956. By 1963, the junior high was overcrowded; Bell Middle School was built to alleviate that situation. By 1988, this building was closed. It has since become the headquarters for the American Alpine Association and the Colorado Mountain Club.

The Golden High School thespians take a break from rehearsals of *Charley's Aunt*, April 1895. GHS is the oldest high school in Colorado, founded in 1873. The first permanent high school building was constructed in 1924, with an expanded facility opening in 1956. Theater and other civic activities are long-standing traditions at the high school.

Pictured is the Golden High School graduating class of 1889, from left: Adela Marie Johnson, Arthur Humphrey Osborne, Bertha Emma Presnell, Frances Weiss Sharps, Winifred White, Samuel Emmor Wood, and Mr. William Triplet.

Grace Jameson and her mother, Gertrude, enjoy a quiet moment c. 1890. During the 1890s, Grace became a certified Jefferson County teacher. She taught the fifth and sixth grades in Golden, a task for which she earned $60 per month in 1897. Grace was the daughter of Judge Alexander Jameson.

Mining schools were rare in the U.S. But following the gold discoveries in California, Nevada, and Colorado, they were becoming very much in demand. In 1869, Bishop George Randall, of the Episcopal Church, founded Jarvis Hall, a liberal arts and theology college, on the outskirts of Golden. By 1872, a second building, Mathews Hall, was added. Randall convinced the Territorial Legislature to financially support his efforts and a School of Mines was completed in 1873. The school separated from Jarvis in 1874 and became the Territorial School of Mines. It passed into control of the State of Colorado in 1876. The Hall of Engineering was constructed in 1894 and still serves the campus as a classroom and lab building.

Guggenheim Hall, to the left in this image, opened its doors in 1906. It is perhaps the most recognizable structure of the CSM campus, sporting a dome of beaten gold on the bell tower. The gold represents the golden age of mining, one of the core study programs at the university. The building houses administration offices.

Sports were an integral part of student life at the CSM campus; strains of the unofficial school song "A Rambling Wreck from Golden Tech" might be heard wafting over the football field in 1890. Long-standing rivalries still exist between Mines and the University of Colorado and the University of Denver.

Since 1908, refurbishing the "M"-blem of the Colorado School of Mines has been a freshman class tradition. It was electrified in 1932, and remains as the world's largest illuminated school insignia—some 104-by-107 feet.

The "M"-blem has long been a target of the animosity between CSM and its rival colleges. Over the years it has been commonplace for a visiting sports team's fans to alter the "M" in honor of their team. One year Mines students caught the would-be vandals and, with a mild acid, etched an "M" into the foreheads of the individuals—a temporary reminder not to mess with the M-blem.

Founded on the former site of the State School of Mines, the State Industrial School was intended to reform "the youth of the State who have become unmanageable at home and disorderly abroad." Of the first 22 boys sent there in February 1881, 3 of them escaped within 6 weeks. Rewards for escapees ranged from $20 to $25. In addition to correcting the discipline problems of Colorado's youth, the State Industrial School also sought to teach the boys a trade, including animal husbandry, tailoring, carpentry, and shoe making.

The Industrial School functioned well as a self-contained environment. The boys were able to grow a great deal of their own food. According to one annual report, the school had 140 apple trees, 25 pear trees, 12 plum trees, and 1,500 blackberry bushes. That year the kitchens pickled 8 barrels of sauerkraut and 6.5 barrels of pickles, made 150 gallons of jelly, and canned 600 quarts of tomatoes.

The young offenders were not strictly confined to the grounds of the Industrial School. They were able to make road trips, such as this one for the band who played for the Armistice Day parade in 1918. The band was formed in 1885 with the loan of 17 instruments from the state. A Captain Williams headed them up.

Nine
GOLDEN MOMENTS

Businesses in a bustling frontier town rarely had only one function. For example, the Boston Company served as not only a mining supply store, but also as the newspaper publisher and the post office. J.H. Linder Hardware bore that distinction as well. Their sidelines were heating and plumbing. In 1892, they plumbed a new cottage at the State Industrial School; in 1896, they installed the City of Golden's new sewer line; in 1903, they installed heating and plumbing for the Methodist Episcopal Church's renovation; and in 1914, they extended the city's water mains.

Golden has always been a unique town, much like the West in which she arose. She does things in her own fashion, her own unique way. A combination of individuals, institutions, and circumstances has created a town that is unlike many others in the nation. Families that came here over a century ago are still represented in the modern population. Even Golden's past is unusual. Vanover Park, a scenic downtown picnic spot, is named for a local saloon owner and problematic drunk who was hung in a moment of 1800s vigilante justice. William "Buffalo Bill" Cody was literally kept on ice for six months between his death and his burial. This chapter is devoted to the often quirky, always individual, side of Golden's life and people.

Horace Tabor came west from New England in 1859 with his young, pregnant wife, Augusta, and a few fellow speculators. The men had grand designs of becoming very rich from the ground littered with gold. Following the baby's birth in Kansas, the Tabors continued on to Golden City. Leaving Augusta and baby Maxcy alone in Golden, Horace continued on to Gregory's Diggings in Gilpin County. Augusta is considered to be one of only about three dozen women in the Colorado Territory at that time. The Tabor family eventually began making the circuit of mining towns, seeking their fortune. Tabor remained very active in Golden's development. He headed up the Lookout Mountain Railway and Telegraph Company, a failed business venture seeking to develop a summer resort on the mountain; and he was part of the Golden water system project. The Tabors wealth eventually came from the Little Pittsburgh Mine in Leadville, in the form of silver, not gold.

On May 21, 1874, the cry of "Fire!" exploded 28 miles up the Clear Creek canyon from Golden City. Central City, the mining capital of the territory, was burning. Within 45 minutes of the fire's outbreak, Golden's Excelsior Fire Company had their equipment loaded onto train cars to assist with the conflagration. Sadly, when they arrived with their brand new pumper apparatus, there was no water for them to fight the fire. Central City was a near complete loss.

This very unique drinking fountain was given to the City of Golden in 1905. It cost $150 and was installed by J.H. Linder Hardware. The fountain, made of cast iron and painted green, sported a brass ball on top and a separate dog drinking fountain at its base.

The blizzard of December 5, 1913, stands as the worst snowstorm on record in Jefferson County. Depths varied from town to town, but all were between 46 and 65 inches. Drifts of over 12 feet buried houses and collapsed buildings. Three hundred men were recruited to dig out the Interurban lines from Denver to Golden. Forty men dug out Golden's main street, Washington Avenue. The *Colorado Transcript* reported that, "The storm had its start in central Arizona. It is hoped that Arizona will never again start anything she can't stop."

On July 24, 1896, a sudden torrential rainstorm caused a series of flash floods down several dry arroyos along the Front Range. Golden sits at the confluence of two of these gulches that were inundated. The resulting flood, named after the Tucker Gulch, killed 29 people and destroyed all of the bridges across Clear Creek, cutting off the north side of town from the south side. Other towns in the immediate area were hit equally hard. It remains as one of the worst natural disasters in Jefferson County history.

Fishing, hiking, camping, and picnicking were all popular pursuits in Golden a century ago when Ruth Hoyt bagged her first trout. Not much has changed. While there aren't as many fish in Clear Creek, hiking trails are crowded, and camping spots must be reserved in advance, Golden is still an outdoor enthusiast's paradise.

The Bicknell family came to Golden from their home in Devonshire, England, in 1890. Sarabelle Bryant, pictured here, became the second wife of John Henry Bicknell in 1901. They had been in school together at Golden High. That same year her mother married Henry Bicknell, John's father. John went on to assist in the building of the Colorado School of Mines "M-blem."

The Festival of Mountain and Plain, organized in Denver in 1895, was an opportunity for residents to gather and celebrate everything that made Colorado great. Golden's Rock Flour Mill and Table Mountain Gardens prepare their wagons for the festival parade. The Garden's sign reads, "We sit under our own vine and fig tree." (Courtesy of the Denver Public Library Western History Collection.)

This commemorative button from the Festival of Mountain and Plain in 1899 depicts the Festival Queen. The event also boasted elaborate parades, a masquerade, a Silver Ball, and a Silver Serpent, with attendants, representing the metal that made Colorado great. The last festival was in 1912.

Perhaps these youngsters are looking to trade in their burro cart for a ride on the Interurban. Pictured behind them is the depot for the Denver, Lakewood, & Golden Railroad Depot, an electric railcar line.

The Lava Lane Dance Hall burned down in 1927. Although the structure was frame, the fire was considered to be of a suspicious origin. Due to the lack of roads to the top of Castle Rock, no fire fighting equipment could possibly get to the top of the mountain soon enough to spare the building. Rumors abound that the fire was set by the Ku Klux Klan in retaliation for being kicked out of their long-time meeting place.

Mary Hoyt was the granddaughter of two of Golden's earliest pioneers. The family operated the Johnson House, one of Golden's first hotels. Mary was a member of the Mt. Lookout Chapter of the Daughters of the American Revolution and became the librarian at the Colorado School of Mines. She was responsible for re-opening the Jefferson County Pioneer Museum in 1953.

Founded in 1920, the Golden Chamber of Commerce was organized by Golden's businessmen to promote "the prosperity and general welfare of the greater Golden area." The chamber and its cooperative organization, the Golden Visitor's Center, have always enthusiastically promoted the town's many businesses and attractions. (Mission excerpt courtesy of the Golden Chamber of Commerce.)

Periodically, the U.S. Bureau of Mines would come into town in their private railcar to inspect the safety equipment of the Colorado School of Mines students. These boys hold the diving helmets that were used with primitive air tanks to provide oxygen inside a contaminated mine. The college has long run its own experimental and training mine, the Edgar, in Idaho Springs, Colorado.

College life is not always the drudgery of study; sometimes sporting events are in order. A Colorado School of Mines football player meets Blaster, the school mascot, in a four-point stance. No word on the outcome or the score of this match. (Courtesy of the Denver Public Library Western History Department.)

Lu and Ethel Holland purchased the La Ray Hotel in 1946, in order to escape the hustle and bustle of the Denver restaurant scene. The newly renamed Holland House became renowned for their homemade pies and biscuits, as well as the wonderful local artwork that adorned the walls. The Holland House was sold following the death of Lu Holland in 1981. It remains a part of Golden's landscape, under the new moniker of the Table Mountain Inn. (Courtesy of the Holland Family.)

Many people moved to the West for the beauty of the great outdoors. John Walker recalled that, "It was quite the thing to ride out on the trolley, and then hike up Clear Creek; folks made a real event of it." Both the family group and the women are hiking the railroad tracks along the creek.

The Teepees opened in the Genesee area southwest of Golden in the 1950s, the period when a glorified and often stylized image of the West was all the rage. It contained a curio shop and a rattlesnake pit. Admission to the pit was 50¢. The shop closed and was demolished during the early 1970s.

Constructed over the swimming pool, the Golden Plunge, Dud's was a favorite restaurant and saloon. During the 1950s, the Golden Fire Department unofficially named it the Long Branch Division Station #3, indicating the favored locale for off-duty firefighters to meet and relax. A Golden firefighting family owned the tavern, for a time. (Courtesy of the Young Family.)

The Jolly Rancher candy plant has always been located in Wheat Ridge, Colorado, though the first store was in Golden. Early batches of Fire Stix were hand-made in the copper kettles, then turned out onto large aluminum tables to be rolled thin and cut into the distinctive rectangle. After the candies cooled they were wrapped, boxed, and shipped throughout the West. It took several more years before the candies were discovered by the East Coast. (Courtesy of the Harmsen Family.)

Denver artist Bob Cormack designed much of Jolly Rancher's early artwork, especially box designs and cartoons. In 1963, the Disney animator drew this map to direct customers to the shop at the Sugar Bar Ranch in Wheat Ridge. He was quoted as saying, "I don't want any of the candy customers missin' the turn and gitten' lost." (Courtesy of the Harmsen Family.)

The vistas of Golden are still pretty much the same as they were back in the 1870s. The impressive edifice of Castle Rock looms over the eastern edge of town, beckoning hikers, mountain bike riders, and rock climbers to attempt the climb. Houses speckle the hillsides of all of Golden's mountains, civilization attempting to make inroads into the domains of the black bear, mountain lion, elk, and mule deer. But nature still intrudes, bears make nocturnal visits to unguarded trash receptacles, the occasional mountain lion surprises a hiker, and elk herds obstruct traffic along a busy thoroughfare; Golden's residents would not have it any other way.

Pictured is Washington Avenue, Golden's main street. Distances, locations, and growth are somehow all measured off the "Ave," as it is lovingly called. The view down the Ave has changed a little over the last century and a half. Many of the old buildings are gone, replaced by newer, bigger, and better. The streets are paved. The trolley tracks were pulled up decades ago. Some residents see this as positive progress, others as negative growth. Just as Golden experienced growing pains in the 1870s, she has them again. Progress is inevitable, change is optional. Regardless of what path she follows, Golden will undoubtedly remain the town Where the West Lives.

The End.